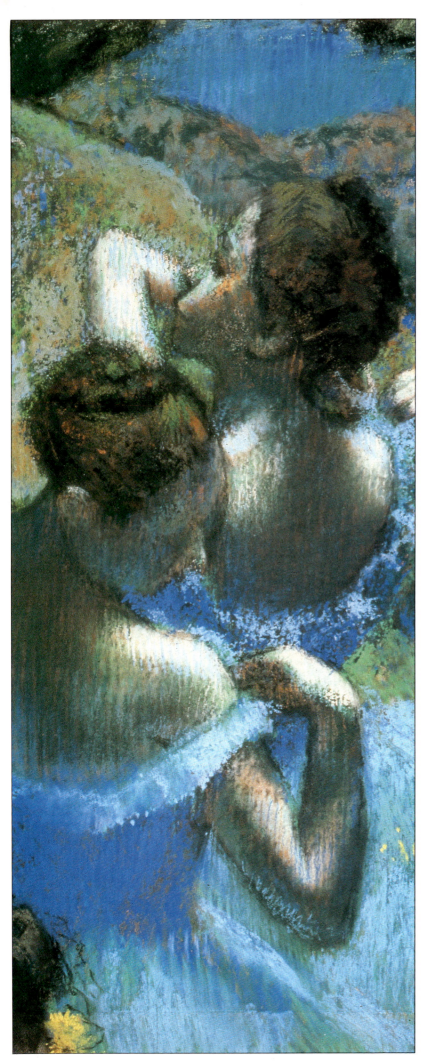

Important events in the life of

Edgar Degas

1834 Hilaire-Germain-Edgar Degas born on 19 July.

1845 Starts to attend Lycée Louis-le-Grand in Paris.

1847 His mother dies.

1855 Enters Ecole des Beaux Arts. He meets Ingres.

1856-60 Travels often to Italy and studies the work of the Old Masters.

1861 Meets Manet whilst copying a painting in The Louvre.

1870 Joins the National Guard to defend Paris from the Prussians.

1872 Travels to New Orleans.

1874 His father dies. Degas is one of the organisers of the First Impressionist exhibition.

1880 Works increasingly in pastel, experiments with essence. Begins to model in wax.

1881 Creates *The Little Dancer*.

1886 Exhibits at the eighth and final Impressionist exhibition.

1890 His eyesight failing, Degas spends more time making models.

1893 Has his only one-man exhibition at the gallery of Durand-Ruel.

1897 Falls out with many friends over the Dreyfus case.

1917 Degas dies on 27 September.

Matthew Meadows

An introduction to
Edgar Degas

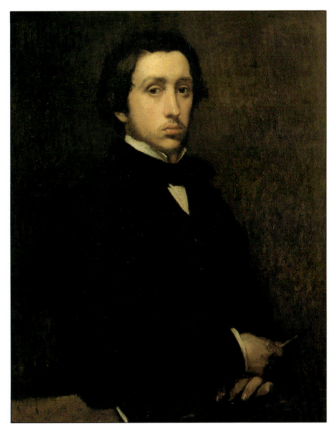

Self-portrait, 1854–55

an imprint of Hodder Children's Books

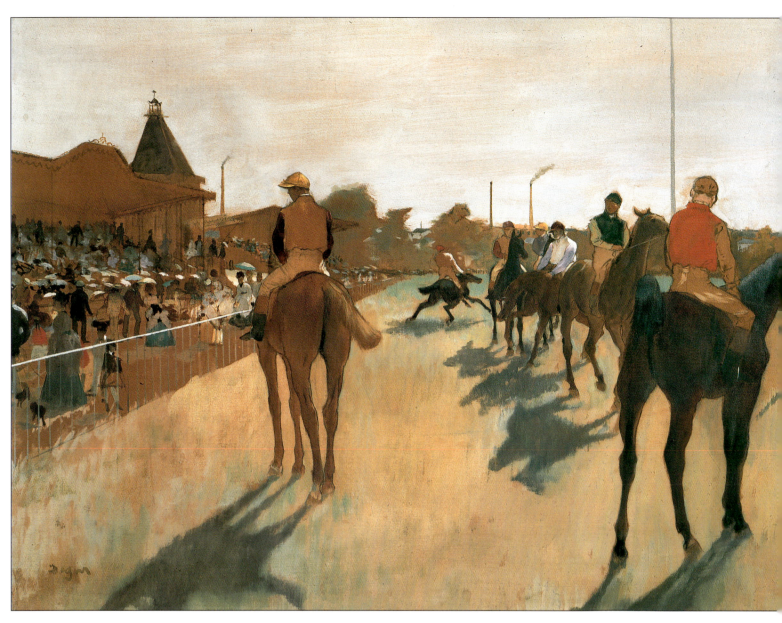

At the Races, in front of the stand, 1868
Horse racing was a new and popular sport in France when Degas painted this picture. It became one of his favourite subjects. Here we see the spectators, jockeys and horses waiting for the race to begin, rather than the race itself.

Cover: The Dancing Class, 1874

End paper: detail from The Dancers in Blue, 1899

Paintings in this book are identified by their title followed by the artist who painted them. If no artist is named the painting is by Edgar Degas.

This book was prepared for Macdonald Young Books Ltd by Tucker Slingsby Creative Services
London House
66–68 Upper Richmond Road
London SW15 2RP

Project Editor: Jackie Fortey
Picture Researcher: Liz Eddison
Design concept by
M&M Design Partnership
Designer: Steve Rowling
Artwork: George Fryer, Bernard Thornton Artists

Consultant: Tom Parsons

Subject Adviser
Professor Arthur Hughes
Department of Art, University of Central England, Birmingham

First published in Great Britain in 1996 by Macdonald Young Books Ltd
This edition published in 2001 by Hodder Wayland, an imprint of Hodder Children's Books

© Hodder Wayland 1996

All rights reserved

Printed by GRAFIASA S.A., Porto, Portugal

Acknowledgements
Bridgeman Art Library: Front Cover: Giraudon/Musée D'Orsay; Front End Paper: Pushkin Museum, Moscow; Giraudon 4, 8; Louvre Paris 6, 9b, 11; Private Collection 10l; Stapleton Collection 10r; Musée D'Orsay 9, 12, 15, 17, 27t; Musée De Beaux-Arts 13, 16; National Gallery, London 19, 22; Hermitage, St Petersburg 23; Fitzwilliam Museum, University of Cambridge 14, 24l; National Portrait Gallery/Smithsonian Institute 24r; Hermitage, St Petersburg 27b; Pushkin Museum, Moscow 29.

Musée D'Orsay/Reunion des Musées Nationaux: Title Page, 7, 26, 28.

Louvre/Reunion des Musées Nationaux 20, 25t.

Tate Gallery, London 21.

A catalogue record for this book is available from the British Library.

ISBN 0 7502 3523 3

Contents

The Degas family	6
History paintings	8
An artist in Paris	10
American cousins	12
Backstage at the ballet	14
Women at work	16
In performance	18
Starting to sculpt	20
Working indoors	22
Printer's ink	24
'A blind man's craft'	26
A lonely twilight	28
More information	30
Index	31

The Degas family

Hilaire-Germain-Edgar Degas was born in Paris in 1834 and was the eldest of five children. His mother was a Creole from New Orleans, America, where her father grew and exported cotton. Her family were French. Degas' father was half French, half Italian. He ran the Paris branch of the de Gas family bank.

Both families were well-off and Edgar had a comfortable and privileged upbringing. His parents were interested in music and the arts, and his father had friends among the art collectors of Paris. This was to help Degas later, when he was studying art.

Soon after coming to Paris, Degas' father changed his surname from Degas to de Gas. He did this to show that the family's ancestors were aristocrats. Edgar eventually took back his proper surname. When Degas was 13, his mother died. His father never remarried.

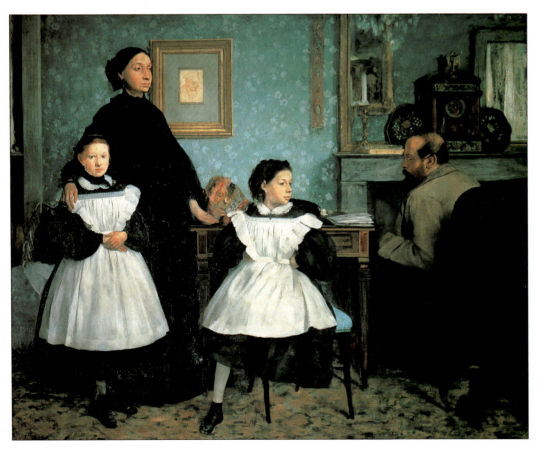

◀ **The Bellelli Family, 1858**
Degas visited his aunt and her husband in Florence in 1858-9. His aunt, Laure, is shown expecting another baby. She is also in mourning for her father René-Hilaire, who has just died. Laure's face is solemn and sad. Her husband is placed far apart from her, with his back to us and his eyes looking down. By doing this, Degas is showing us that their marriage is not a happy one.

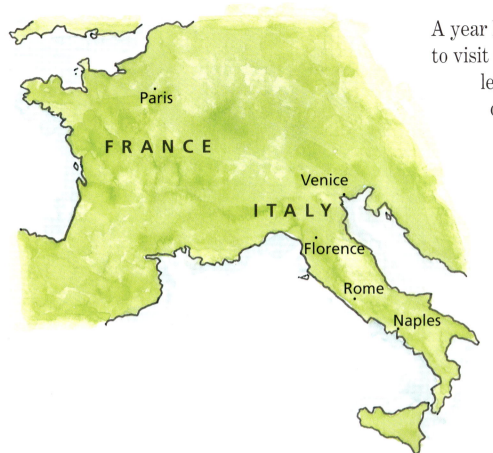

A year later, Degas left for Italy to visit his father's family and to learn about Italian art. He described his three years in Italy as 'the most extraordinary period of my life'. He visited people and places all over Italy, and saw many great works of art. It was an experience that would shape his own work in the years to come.

In 1845, Degas was sent to Lycée Louis-le-Grand, an exclusive boys' school in Paris. Here he made many friends, including Henri Rouart who he was to meet again many years later.

Although his favourite subject was art, Degas' father made him study law. While Degas was studying, he visited the Louvre in Paris as much as he could, to copy the drawings of the Old Masters. By 1855, he had persuaded his father to let him study art.

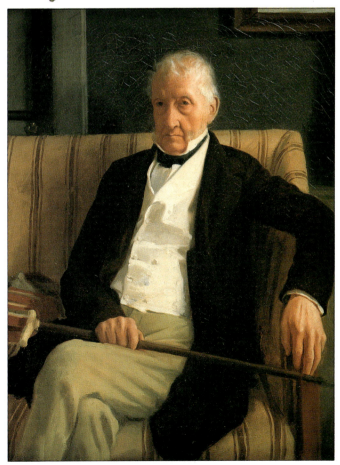

▶ **René-Hilaire Degas, 1857**
Degas painted this small portrait of his grandfather, René-Hilaire, when he stayed with him in Naples.

History paintings

When he returned from his travels, Degas' mind was full of all of the works of art and ancient buildings he had seen in Italy. He began work on a series of large history paintings.

Paintings showing scenes from history had been popular with artists in the past but were thought old-fashioned by many of Degas' fellow artists.

Degas probably met the artist Edouard Manet in 1861, while sketching in the Louvre. They became friends, although they had some disagreements. Manet laughed at Degas for doing history paintings. They also quarrelled over Degas' portrait of Manet listening to his wife at the piano. Manet did not like the way Degas had painted his wife.

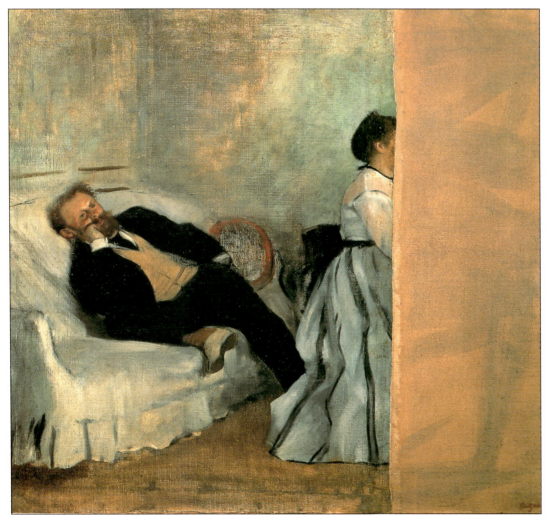

◀ **Monsieur and Madame Edouard Manet, 1868-9**
This painting by Degas was damaged by Manet himself, who cut off the right hand side because he disliked it. Degas was offended and took the painting back from Manet. Degas also sent back a small painting of plums Manet had given him.

■ *The position of the figures in this double portrait tell us something about the Manets. Manet leans on the sofa, looking rather bored, while his wife plays the piano.*

▶ **Semiramis Building Babylon, 1860–62**
In this painting of a scene from ancient history, the beautiful queen Semiramis gazes over the splendid city of Babylon. She is accompanied by her ladies and they are all dressed in elegant clothes. Degas is already showing his interest in painting strong female characters. This is to remain with him throughout his life.

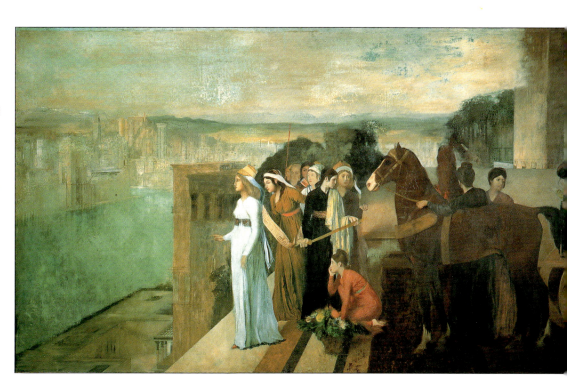

In 1860, an opera about Semiramis, the queen of ancient Assyria, opened in Paris. This opera could have given Degas the idea for the first of his large history paintings.

Degas did five history paintings in all. Even when he moved on to new, more modern, subjects, he was proud of these pictures. All his life he admired the great works of the Italian painters of the 15th and 16th centuries and the traditional paintings of the artist Ingres who had been his teacher.

▶ **Bather, Jean-Auguste Dominique Ingres, 1808**
'Draw lines, young man, draw lines,' Ingres is supposed to have said to Degas. Degas never forgot these words.

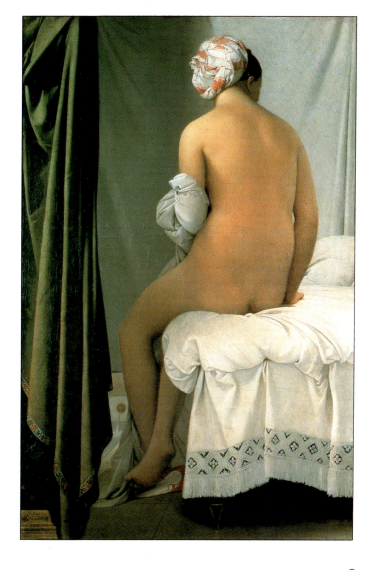

9

An artist in Paris

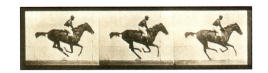

Degas was 28 when he met Manet. Manet was part of a group of artists called the Realists. The Realists painted pictures of modern life, rather than subjects from the past, and were interested in trying out new ways of doing this. Older artists disapproved of their work and would not allow it to be shown at the Salon. The Salon exhibition, held every year in Paris, was a chance for artists to become known and to sell their work.

Although Degas' paintings continued to be shown at the Salon, unlike those of Manet and his Realist friends, Degas stopped sending them in. He felt he had more in common with the artists who were experimenting with new techniques. In particular he admired the work of the Impressionists. These artists tried to paint the impression or effect a place or person had on them.

Manet encouraged Degas to choose subjects for his pictures from city life and popular pastimes, such as horse-racing. Degas painted the races themselves, but other smaller scenes also caught his eye. He shows us restless grooms and jockeys, frisky horses and bored spectators.

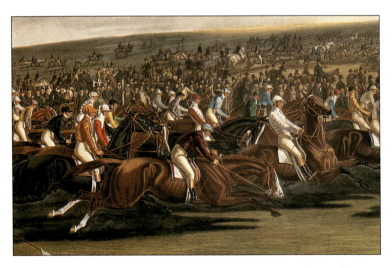

▲ The Start of the Memorable Derby of 1844, John F. Herring Snr
In English sporting prints, horses were shown galloping with legs outstretched, all four hooves off the ground.

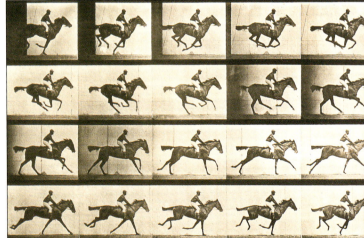

▲ Animal Locomotion, Eadweard Muybridge, 1887
These photographs show how a horse's legs really move when it gallops. Degas changed the way in which he drew horses after seeing this.

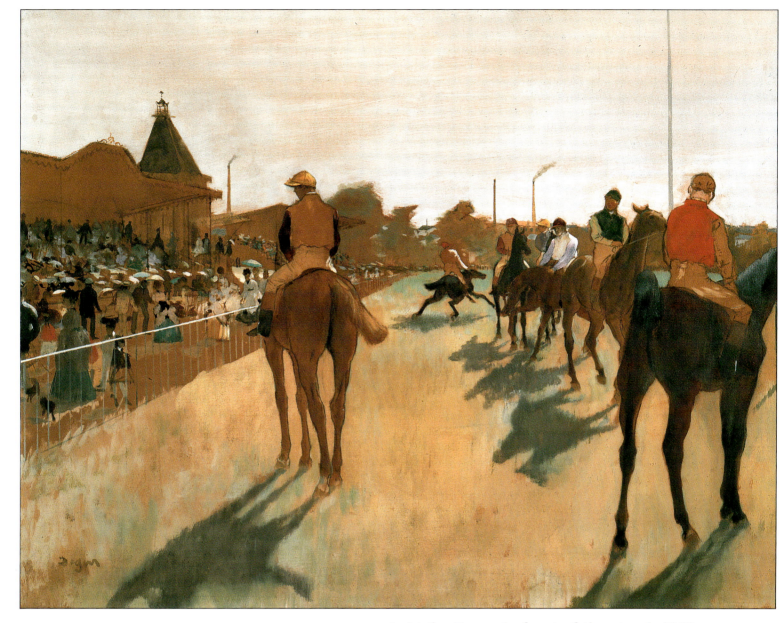

▲ **At the Races, in front of the stand, 1868**
Horses and riders wait about before the race begins. Their strong shapes cast dark shadows on the bright, sunlit ground. At the centre, a horse breaks into a gallop, its legs outstretched as in the English sporting print which can be seen opposite.

Degas was always on the look-out for new ways to give a feeling of action. He often did quick, unfinished sketches to give a sense of movement. He was also interested in photography and his subjects sometimes look as though they have been caught by a camera in an unposed 'snap-shot'.

Degas did not look at a scene or person straight on when he was painting a picture. He chose unusual angles and poses for his subjects.

■ *Using oil paints can be a slow process for an artist. They take a long time to dry. Degas invented a new technique called 'essence' so that he could work more quickly. He used blotting paper to soak up some of the oil, and then he mixed the paint with turpentine to make it dry more quickly.*

American cousins

In 1870, war broke out between France and Prussia (now part of Germany). Both Degas and Manet were too old to be called up. However, when the Prussians reached Paris, they both volunteered to fight.

Degas found that an old school-friend Henri Rouart, was the captain of his regiment. During the war, which lasted only six weeks, Degas realised that something was wrong with his eyes and his sight got worse from then on.

▲ Edgar and René travelled across the Channel to Liverpool then sailed for America.

After the war, Degas travelled with his brother René to visit his mother's family in New Orleans. The crossing to New York from Liverpool took ten days. Then they went on to New Orleans, in the far south of America, by train.

During his five-month stay in New Orleans, Degas lived in the house of his uncle, Michel Musson. He went to visit his uncle's cotton plantations. However he had to spend much of his time indoors because, by now, bright light hurt his eyes.

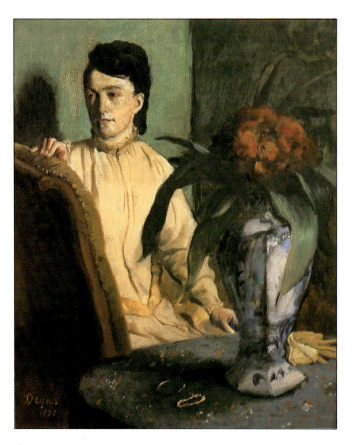

◀ **The Woman with the Oriental Vase, 1872**
When he was in New Orleans Degas painted this portrait of an unknown woman, sitting behind a large vase of splendid tropical flowers.

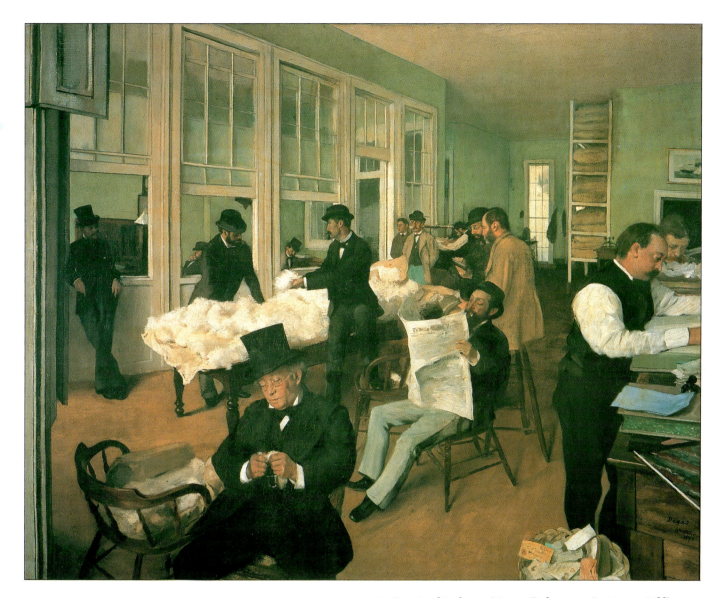

▲ **Portraits in a New Orleans Cotton Office, 1873**
Although this is a small painting, Degas has painted 14 men in different poses. One examines the cotton, another fills in account books and others talk business. Degas' uncle is at the front and his brother René leans back against a chair, reading a newspaper.

Degas was fond of his family and he painted portraits of his cousins and nieces, but he was soon homesick.

One of Degas' best paintings from his visit to New Orleans is of Michel Musson's offices. It was taken back to Paris and exhibited at the Second Impressionist exhibition in 1878, where it was bought by a French museum. This was the first time one of Degas' works had been bought by a museum.

■ *There is lots of activity in this picture but the scene is business-like and orderly. Degas has used a pattern of greens, browns and blacks, with a few touches of blue, to give a feeling of calm and quiet.*

13

Backstage at the ballet

Degas returned from New Orleans to his busy life in Paris. One of his favourite pastimes was going to the Opera and, like his father, he was a season-ticket holder or 'abonné'. An abonné was allowed to watch the ballet dancers rehearsing.

The foyer at the Opera was the biggest rehearsal room of all. Its wooden floor sloped down to a huge mirror which completely covered one wall. Here, Degas studied and drew the movements of the dancers. He liked to watch closely and make quick sketches. He would then use these studies and his memory to create a painting when he was back in the peace and quiet of his own studio.

In 1874 Degas' father died and the family discovered that the bank was having financial difficulties. There were business debts to pay and Degas decided to restore the family's honour by repaying these debts himself.

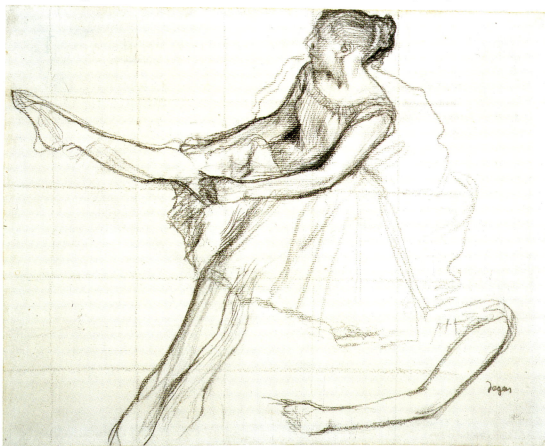

◀ **Dancer adjusting her tights, 1880**
This is one of many quick sketches Degas made of dancers at rehearsals. He would use several of these sketches or 'studies' to compose the scenes in a finished painting.

■ *To enlarge and transfer his drawings on to canvas, Degas used the method called 'squaring up'. He drew a square grid over his sketches and placed a larger one over the painting. He then copied the drawing square by square.*

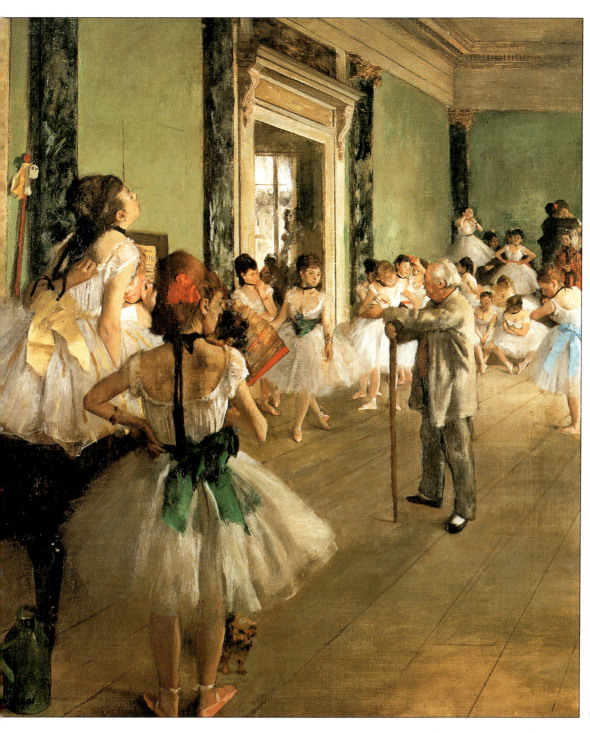

■ *The painting is arranged with the studio floor rising steeply from left to right. This leads us into the picture. The way in which this painting is organised results from Degas' interest in Japanese prints. He was always quick to experiment and to use new ideas in his paintings.*

▲ **The Dancing Class, 1874**
Degas catches a private moment in the class. A dancer scratches her back, a small dog sniffs the leg of another, other dancers chat or adjust their dresses. Meanwhile the elderly dancing master Jules Perrot leans on his stick, with his face in shadow. You will find Degas' signature on a green watering can to the left of the picture. At the time this was painted, informal poses such as these would not have been thought to be the correct subject for a painting.

For the first time in his life, Degas had to earn his living from painting. He started by selling his collection of work by other artists, but, as things got worse, he had to sell his own pictures too. His ballet pictures proved to be very popular and many were sold. The de Gas family Bank finally closed down for good in 1879.

15

Women at work

Although he is supposed to have disliked women, they were one of Degas' favourite subjects. In his paintings he shows many different women – from dancers to laundresses.

▲ **Opéra, Paris**
The Opera House in Paris was one of Degas' favourite places.

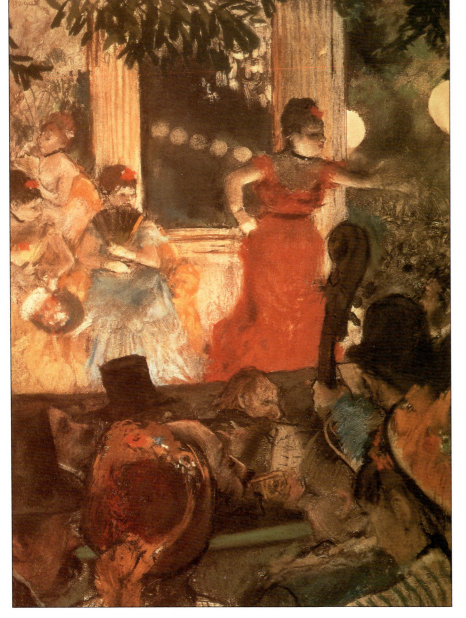

◀ **Café-Concert at the Ambassadeurs, 1875**
Degas shows Parisians gathered in the *Café des Ambassadeurs* for an open air café-concert. The lively scene is lit by the glow of hanging gas lights. He draws us into the audience as we look up at the stage from below. Bright colour on the ladies' hats and in the singers' dresses stands out against the men's black top hats and the strong outline of the top of the double bass.

■ *Degas sometimes liked to draw in pastel over a monotype print (see page 28), as he has done in this picture. The grey background colour of the monotype shows through the brighter pastels.*

In the 1870s people were flocking into the city of Paris to find employment in the new factories. The villages that surrounded Paris were swallowed up by suburbs. After the war with Prussia the centre of Paris was rebuilt, with wide streets called boulevards.

Paris became known as the city of pleasure. More people had money to spare and liked to enjoy themselves. Parisians spent their free time at the races, eating and drinking in bars and cafés, shopping, or simply strolling along the boulevards.

The new Opera House, with its plays and ballets, was for those with more expensive tastes, but almost everyone could afford to go to a café-concert. Here, you were entertained while you had a meal or a drink. Degas captured these colourful occasions in a series of paintings of café-concert singers.

In contrast to these happy evenings, Degas also made studies and paintings of laundresses hard at work. At that time most people sent their washing to a laundry. Degas' pictures show how bored and tired the laundresses were.

▶ **Two Laundresses, 1884**
Laundresses in Paris in Degas' time worked very long hours in very hot and steamy conditions. The woman on the left is holding a bottle of water which was used to cool the irons. The other bends over, pressing hard on the heavy flat-iron.

■ *The figures in this painting are shown as simple shapes with little detail. The paint does not completely cover the rough texture of the canvas underneath.*

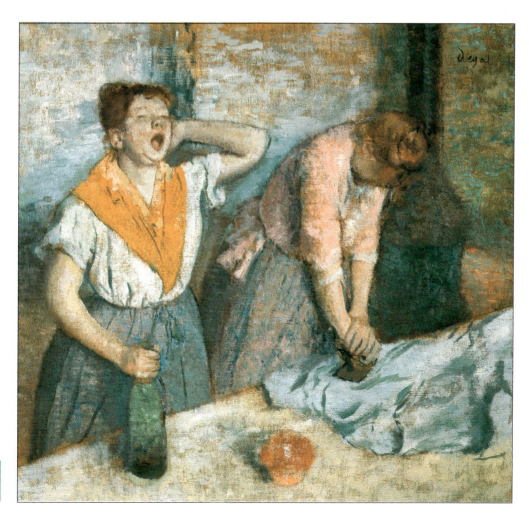

In performance

Degas was interested in different kinds of performances. As well as the opera, ballet and concerts, he and his friends enjoyed going to the Fernando Circus. This was opened in Paris in 1873 by Ferdinand 'Fernando' and his group of Spanish acrobats. It became a popular subject for artists until it closed, almost 30 years later.

Degas saw the famous performer, Miss La La, four times early in 1879 and did several drawings, both of her and of the inside of the circus.

The part of her act he liked was when she soared up into the dome. Gripping the rope in her teeth, she spun slowly round, as she was hauled upwards.

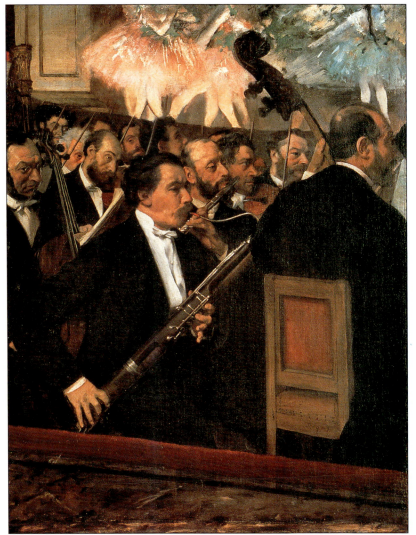

◀ **Orchestra at the Opera, 1868–69**
This is a group portrait of Degas' musical friends, painted for Désiré Dihau, the man playing the bassoon. The musicians are shown in the orchestra pit at a performance of a ballet at the Opera House.

■ *Degas has arranged the picture in an unusual and striking way. The double bass player to the right has his back to us and is facing out of the picture and the dancers are cut off by the top of the picture. Their brightly lit shapes contrast with the dark colours of the orchestra below.*

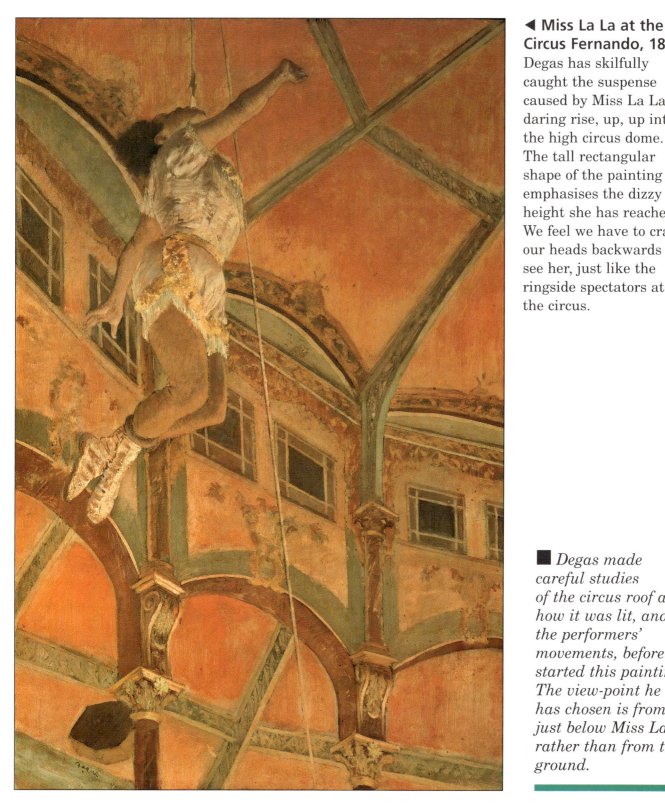

◀ **Miss La La at the Circus Fernando, 1879**
Degas has skilfully caught the suspense caused by Miss La La's daring rise, up, up into the high circus dome. The tall rectangular shape of the painting emphasises the dizzy height she has reached. We feel we have to crane our heads backwards to see her, just like the ringside spectators at the circus.

■ *Degas made careful studies of the circus roof and how it was lit, and of the performers' movements, before he started this painting. The view-point he has chosen is from just below Miss La La rather than from the ground.*

This dramatic moment is the subject of one of Degas' finest paintings, which was shown at the fourth Impressionist exhibition in 1879. People remarked that it reminded them of paintings, on the walls and ceilings of many Roman Catholic churches, of the Virgin Mary ascending into Heaven.

19

Starting to sculpt

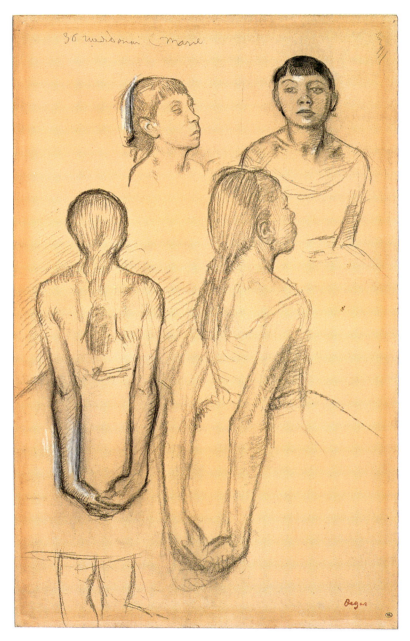

▲ **Four studies of a dancer, 1879**
Degas made charcoal drawings of his model, Marie von Goethen, before he started modelling. These studies show the position of her head and neck from different angles, and her arms pulled back in a difficult pose.

One of Degas' first attempts at sculpture was *The Little Dancer*. His model was 14-year old Marie von Goethen, a Belgian dancer at the Opera. Degas made the model of Marie two-thirds life-size. He drew her several times, showing her awkward ballet pose from different angles. He often drew the human body in this way, exploring how it worked and moved. Using sculpture, he could study balance as well as movement.

The Little Dancer was exhibited at the Impressionist Exhibition in 1881, standing in a glass case. She wore a horsehair wig with a green satin bow, and was dressed in a real tutu and ballet slippers. Many visitors were startled by her life-like appearance. The sculpture was thought to be very modern and daring and made people more interested in Degas' work.

After this Degas began making sculpture regularly, modelling mostly women and horses. The models were seldom more than 50 centimetres high. He often modelled in wax around a wire support called an armature.

■ *First, Degas made a 'skeleton' called an armature from wire, wood or even string. He then built up the main shapes with bits of cork, sponge or cloth. Then he added clay, wax and an early form of plasticine called plastilene to make the body. As you can imagine, the end result was sometimes not very strong.*

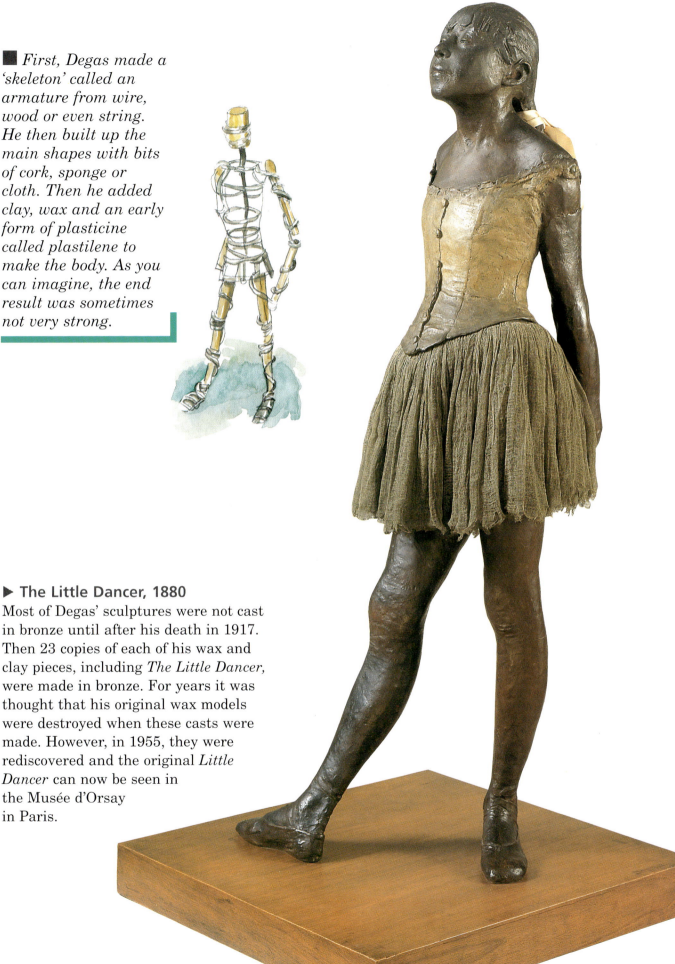

▶ **The Little Dancer, 1880**
Most of Degas' sculptures were not cast in bronze until after his death in 1917. Then 23 copies of each of his wax and clay pieces, including *The Little Dancer*, were made in bronze. For years it was thought that his original wax models were destroyed when these casts were made. However, in 1955, they were rediscovered and the original *Little Dancer* can now be seen in the Musée d'Orsay in Paris.

Working indoors

Although Degas showed his work in seven of the eight Impressionist exhibitions, he disagreed with the Impressionists about some things. The Impressionists were interested in trying to capture the effects of light and colour. To do this they usually painted out of doors where they could watch the light changing and moving.

Degas preferred to work in his studio and most of his later paintings are of indoor scenes. He liked to look at things clearly and scientifically before using them in a painting. Even when he painted a landscape he planned the painting carefully in his studio. He was very concerned with composition – the way in which the different elements in a painting are arranged so they look good together. When he painted the landscape *On the Beach*, Degas said he posed his model on the studio floor wearing an old flannel vest!

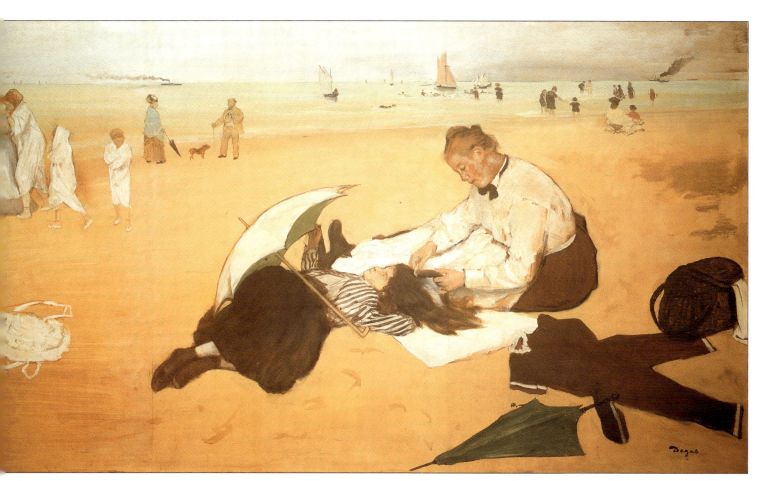

▶ **Woman at her Toilette, 1885**
Degas found a new approach to this subject. His models are in different poses to those used by other artists. They turn away, brushing their hair with strong, active movements.

■ *Pastels are soft chalks which crumble very easily. Degas invented his own way of using them. He would usually draw with charcoal first, then use the point or side of the pastel to cross-hatch and scribble, or smear it with his finger. He even mixed his pastels with water and dabbed them on to the picture like paint.*

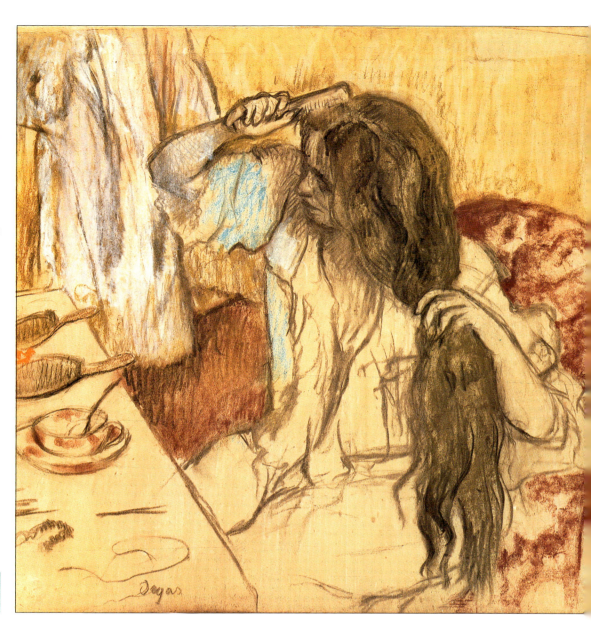

◀ **The Beach, 1877**
Degas has observed all kinds of delightful details in his beach scene. A woman bends over, carefully combing the long dark hair of a young girl. In the background children scurry by, bundled up in towels. Elsewhere a man and woman chat beside a patient dog. If you look carefully at the background, you will see that the smoke from the two channel ferries is streaming in opposite directions!

■ *The beach looks very like a floor with things scattered across it. The way in which all the items are arranged was carefully planned by Degas in his studio. The figures stand out from the landscape, unlike the figures in most Impressionist landscapes which blend in.*

Degas was fascinated by women brushing their hair and he returned to this subject many times in his drawings. The women of his time kept their hair long but pinned it up in public.

Degas used pastels for these drawings and, as his eyesight got worse, he began to do more pastels and less oil painting. Pastels were quicker and easier to use than oils.

Printer's ink

Degas made prints all his life. A print is made by drawing or etching a picture on a surface such as wood or metal. Ink or paint is then brushed over the surface and the design is printed by pressing the surface down on to paper.

Degas' favourite technique was etching which involves using acid to create a design on a metal plate. His etchings were always black and white, although his friend Mary Cassatt worked with colour.

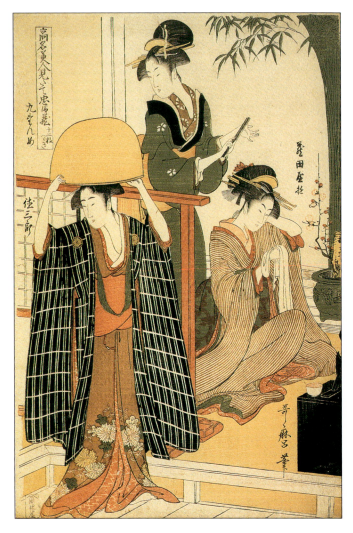

▲ **Comparison of celebrated beauties and the loyal league, Kitagawa Utamaro, 1797**
The work of this Japanese printmaker, with its daring designs, gave Degas and the Impressionists new ideas to use in their own prints and paintings.

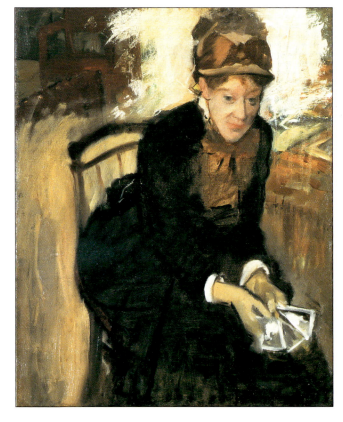

▶ **Miss Cassatt, Holding Cards, 1884**
Mary Cassatt was an American artist who worked closely with Degas. She posed for several portraits, but later took a dislike to this one.

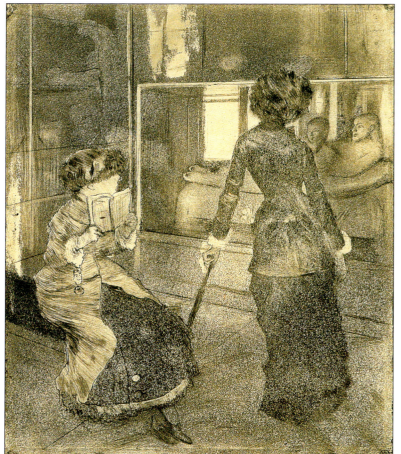

◀ **Mary Cassatt in the Louvre, 1879-80**
Degas did a pastel drawing of this scene and then made a series of black and white etchings of the same subject.

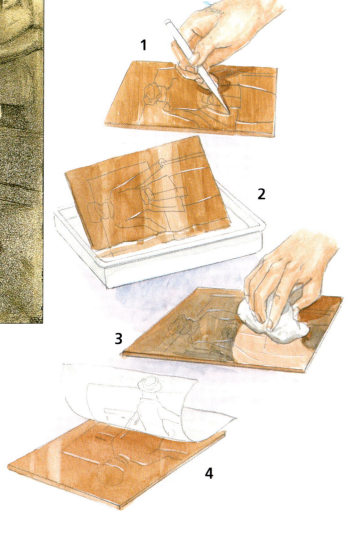

During the 1870s Degas worked with Mary and with Camille Pissarro, trying out different ways of making prints. The Japanese had made coloured woodcuts in Tokyo almost a century earlier. These woodcuts were sold in Paris in the 1860s and Degas bought many of them.

Kitagawa Utamaro and Suzuki Harunobu were two Japanese artists Degas studied and copied. They had various techniques for making their pictures look more 'real'. The figures are cut off at the picture's edge, the view-points are high, shapes overlap and there are strong diagonal lines.

■ **Making an etching**
One way of making an etching is to scratch a design, using a special tool, on to a flat metal plate which has been treated with an acid-resistant covering (1). When the plate is dipped into acid, the acid bites into the surface where it has been scratched, making the lines of the design rougher and deeper (2). Thick, sticky ink is then wiped over the plate. When the ink is cleaned off (3), some is left in the etched lines. A piece of paper is pressed on to the plate and the design appears in mirror image on the paper (4).

'A blind man's craft'

During his 50s, Degas' eyesight became weaker. He began to make more sculptures because it was easier for him to model with his fingers than to paint or draw.

When he did draw, because he could no longer see details, Degas started using stronger colours and his compositions became simpler. He put one or two figures into his pictures, seldom more.

He continued to use pastels, choosing stronger colours which were easier to see. He also worked from memory, reusing favourite poses that he had created in past paintings.

▼ **The Tub, 1889**
Most sculptures of figures show them sitting or standing upright, but in this one Degas did something very unusual. His sculpture is made so that we look down on the woman washing. In his pastels of women washing themselves, Degas also chose to use unusual viewpoints.

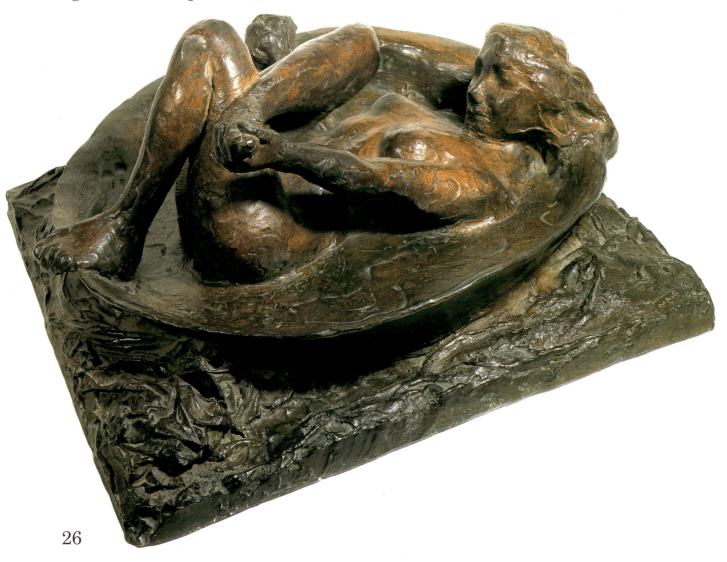

▶ **The Tub, 1886**
In this pastel we look down on a woman who is crouching, washing herself in a tub. It is one of a set of 10 pastels Degas showed at the Impressionist exhibition in 1886.

■ *Degas has used a high view point, looking down on his subject. The line of the table, with jugs and a brush, runs straight upwards across the picture.*

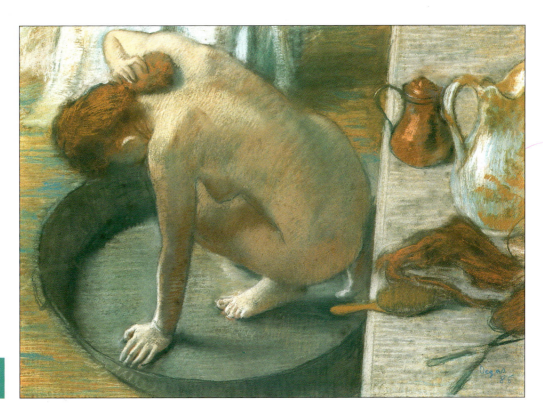

Degas worked in his studio, drawing and sculpting the women who came to model for him. His studio was filled with odd bits of furniture: he used them to create rooms where he posed his models. He would paint his models ironing, brushing their hair or, most often, washing.

Many artists had painted the female nude in the past, but Degas' pictures (known as toilettes) were different. The figures are shown in unusual poses and from unexpected angles. They were not mythological or historical figures but ordinary women. Not many flats in 19th century Paris had running water and washing in the bedroom was an everyday event.

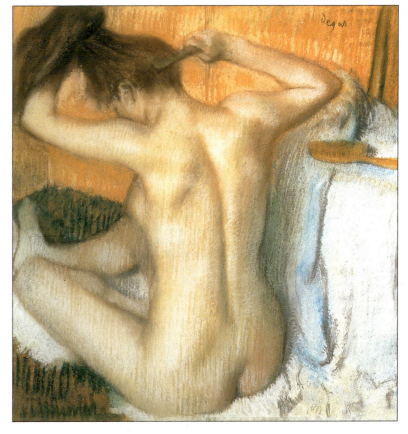

▲ **Woman combing her hair, 1886**
Most of the figures in Degas' pastels stretch their limbs. This was because Degas wanted to be able to draw taut, tense muscles.

A lonely twilight

In 1890 Degas made a trip to Burgundy in eastern France. Here he made some colour monotype pictures, working mostly from memory. The prints were landscapes and proved to be very popular when, two years later, the dealer Durand-Ruel organised the only one-man show of Degas' work ever held.

The prices for Degas' paintings were rising steadily, and he became upset when poorer friends, including the artist Renoir, sold the paintings he had given them. He remained on good terms with the painter Suzanne Valadon, but he fell out with Mary Cassatt, whose work he criticised.

His reputation for being a grumpy old bachelor grew. He became more lonely as some of his old friends died and he lost others through the 'Dreyfus Affair', a scandal about a Jewish officer wrongly accused of spying. Degas became unpopular by expressing strong anti-Jewish feelings.

■ **Making a monotype**
Monotypes are so called because only one print can be made from each plate. (Mono means one.) The artist covers a glass or metal plate in ink and draws a design on it. Alternatively the artist paints in colour on the plate. The plate is then pressed on to paper to make one print.

▶ **Burgundy Landscape, 1890**
This is one of the landscape prints made by Degas late in his life.

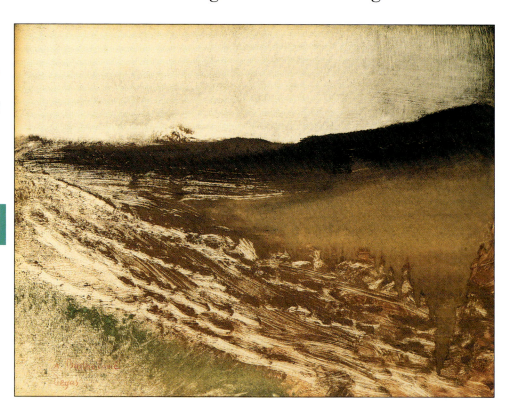

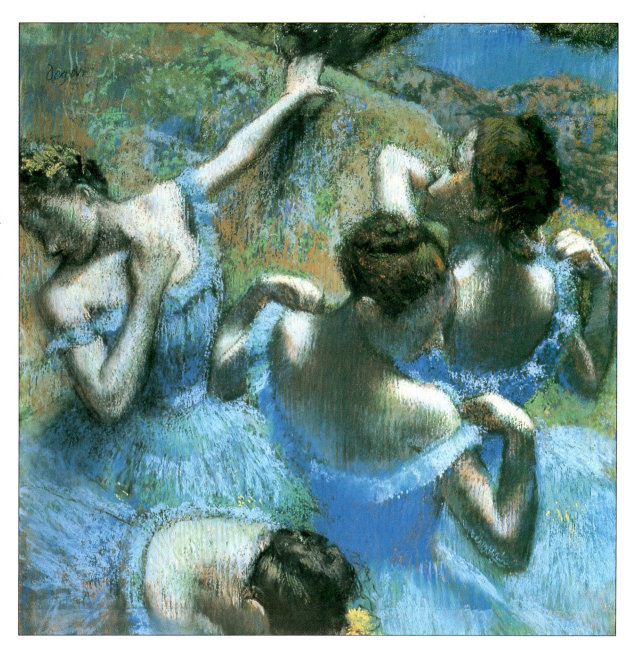

▶ **The Dancers in Blue, 1899**
Degas' sight was nearly gone when he painted this picture. The brilliant blue pastel was rubbed on with his fingers and makes a beautiful pattern on the surface of the picture.

In 1912, at the age of 78, Degas was forced to leave his flat and studio in the rue Victor-Massé, where he had lived and worked for 25 years. The flat was going to be knocked down to make way for a new building.

Degas moved round the corner, but never recovered from this blow. The studio things were never unpacked and Degas spent his remaining years wandering around the streets of Paris.

Although Degas had come to be recognised as one of France's leading artists, his death, on 27 September 1917, passed by almost unnoticed. His country was still caught up with the terrible events of World War I which did not end until the following year and many of his old friends were dead.

The words Degas asked his friend Forain to say at his funeral were: 'He loved drawing, and so do I.'

More information

Glossary

bronze A metal made by combining copper and tin, often used to make sculpture.

canvas Woven cloth on which artists paint with oils.

casting A way of making sculpture by pouring metal (such as bronze), which has been heated to a liquid, into a mould and letting it set.

Creole A person whose ancestors were French settlers in the southern USA.

The Dreyfus Affair A scandal which rocked France. A Jewish army officer called Alfred Dreyfus was wrongly accused of spying.

essence Oil paint is thinned down with turpentine, so that an artist can make rapid, quick-drying sketches.

History painting (also called 'academic painting'). Subjects were usually taken from ancient history or mythology.

Impressionism was an new way of painting which began in France in about 1860. Impressionist artists tried to capture colour and light as we see it in nature and used small dabs of paint and bright colour to build up a scene.

Impressionists Monet, Renoir, Sisley and Bazille were the first Impressionist painters. They were joined by Pissarro, Cézanne, Morisot and Guillaumin, and later Manet.

Impressionist Exhibitions Between 1874 and 1886, eight exhibitions of Impressionist work were held. The critics and general public often made fun of the paintings.

oil paint A kind of paint used by many artists. Coloured substances, called pigments, are mixed with oil (usually either linseed or walnut oil).

Old Masters The great painters of the past, particularly those working in Europe between the 13th century and the 17th century.

pastel Coloured pigments stuck together with gum to make an artist's crayon.

Prussia A powerful German kingdom, which went to war with France in 1870 and laid siege to Paris.

Salon Every year an art exhibition was held by the French Royal Academy of Painting and Sculpture. Judges decided who could show their work.

People

Mary Cassatt (1845-1926) An American artist who joined the Impressionists.

Jean-Auguste Dominique Ingres (1780-1867) One of France's leading painters, who painted many portraits.

Edouard Manet (1832-83) French artist described as one of the founders of modern art. He worked in a style known as Realism, which broke with the past.

Claude Monet (1840-1926) The leader of the Impressionists. He painted flower paintings and landscapes.

Camille Pissarro (1830-1903) A leading Impressionist painter, particularly of landscapes.

Pierre-Auguste Renoir (1841-1919) One of the most popular Impressionist painters, who is famous for his nudes and for his Parisian scenes.

Kitagawa Utamaro (1753-1806) Japanese printmaker, whose designs and choice of subjects influenced the Impressionists.

Index

*Page numbers in **bold** show that there is a picture on that page.*

America 12
armature 20, 21

ballet, 14, 15, 18, 20, 21

Cassatt, Mary 24, 25, 28

de Gas bank 6, 15
Degas' paintings
 At the Races **4, 11**
 The Beach **22**
 The Bellelli Family **6**
 Burgundy Landscape **28**
 Café-Concert at the
 Ambassadeurs **16**
 The Dancers in
 Blue **29**
 Dancer adjusting her
 tights **14**
 The Dancing Class **15**
 Four studies of a
 dancer **20**
 Mary Cassatt in The
 Louvre **25**
 Miss Cassatt, Holding
 Cards **24**
 Miss La La at the
 Circus Fernando **19**
 Monsieur and Madame
 Edouard Manet **8**
 Orchestra at the Opera
 18
 Portraits in a New
 Orleans Cotton
 Office **13**

René-Hilaire Degas **7**
Self portrait 3
Semiramis Building
 Babylon **9**
Two Laundresses **17**
Woman combing her
 hair **27**
Woman at her Toilette
 23
The Woman with the
 Oriental Vase **12**
The Tub **27**
Degas sculptures
 The Little Dancer **21**
 The Tub **26**
Degas family
 parents 6
 René-Hilaire **7**
 René 12
Dreyfus affair 28

essence 11, 30
etching 25
eyesight 12, 23, 26

Fernando circus 18, 19
Franco-Prussian war 12,
 16

hair 22, 23
Harunobu 25
Herring, The Start of The
 Memorable Derby **10**
history paintings 8, 9
horse paintings 10, 11
horse-racing 10, 11

Impressionism 10, 30
Impressionist exhibitions
 19, 20, 21, 22
Ingres 7
 Ingres paintings
 Bather **9**

Italian art 7, 8
Italy 7

Japanese prints 15, 24, 25

landscapes 22, 28
Louvre 7, 8
Lycée Louis-le-Grand 7

Manet 8, 10, 12
Marie von Goethen 20
Miss La La 18, 19
Musson 12, 13
Muybridge, Animal
 Locomotion **10**

New Orleans 12, 13

oil paints 11
Opera 14, 15, 16

pastels 23
Pissarro 24, 25
printmaking 24, 25

Realists 10
Rouart, Henri 7, 12

Salon 7, 11, 30
Semiramis 9

Utamaro, Comparison of
 Celebrated Beauties
 24

World War I 29